A C A D I A

Visions and Verse

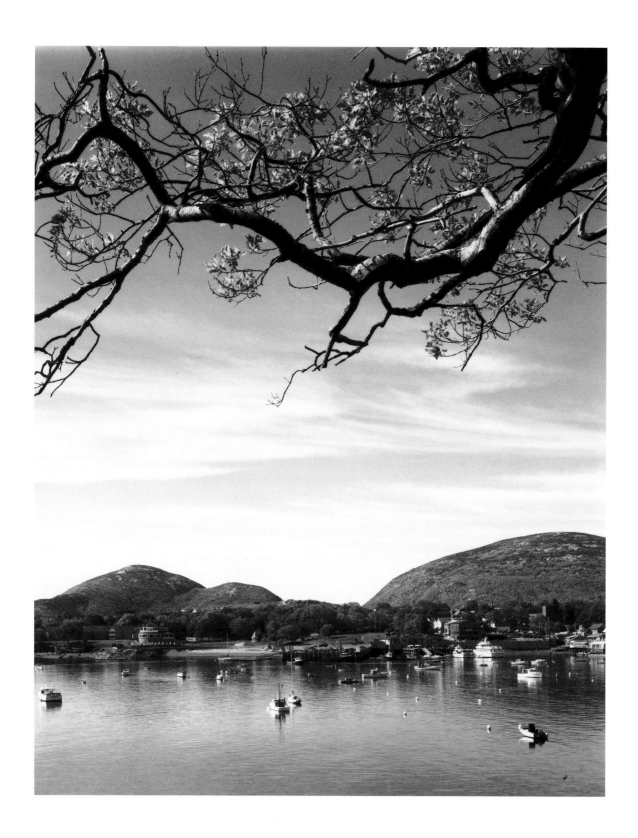

ACADIA

Visions and Verse

Photographs and Poems by

Jack Perkins

Down East Books

Camden, Maine

∽

Copyright © 1999 by Jack Perkins

ISBN 0-89272-469-2

Book design by Peter M. Blaiwas, Vernon Press, Inc., Boston

Separations, printing and binding by C & C Offset Printing Co., Ltd.

Printed in Hong Kong

1 3 5 4 2

Down East Books / Camden, Maine

LIBRARY OF CONGRESS CATALOGING-IN-PUBLICATION DATA

Perkins, Jack, 1933–
 Acadia : visions and verse / photographs and poems by Jack Perkins.
 p. cm.
 ISBN 0-89272-469-2
 1. Landscape photography—Maine—Acadia National Park.
 2. Acadia National Park (Me.)—Pictorial works. I. Title.
 TR660.5.P46 1999
 779'.36741'45—dc21 99-17158
 CIP

This book is dedicated to Mary Jo

As am I

Introduction

Is that the fellow we see now and then on TV? a reader might wonder when seeing the name on the cover. *What's his name doing on a book—especially a collection of photographs and poems?*

Fair questions. Let me explain.

In television, where I've worked for forty years (early as a correspondent for NBC News, later as a host for A&E), pictures and language are what count. The job is to find the right words (but not too many) and array them in the right order to complement, adorn, and animate the right images. In other words, television done correctly is marrying pictures with words.

This book is the same, the same basic process—raised, I hope, to a new level. There are, however, two important differences.

First, the pictures herein are not the work of the superb film and video cameramen with whom I've been privileged to work over the decades (though their keen eyes surely helped inform my own sense of composition and style). Second, unlike the pictures on television, these photographic images last. Look away, look back— they're still here.

When a handsome image appears on transient television (and how rare that is), it doesn't have the decency to stay, but quickly flees. For me, that's always been a frustration—that television pictures and words are as evanescent as morning fog, as reliable as television sincerity. After years of hurling thought and experience into endless ether, I yearned to create something durable.

What an epiphany it was, years ago, to spend time with Ansel Adams at his home and studio in Carmel, California. The purpose of my visit was to produce a television profile on the man whose work has been more broadly disseminated than that of any artist in history, the man who had codified the principles of his craft, writing the books that those who followed had to read.

That time with Ansel Adams planted a seed.

Only years later did that seed finally germinate, after I had retired from daily television and moved with my wife to an island off the coast of Maine. There, I found both the training I needed to pursue Adams's new/old art form and the inspiration that made me want to do so.

I began a series of classes at the world-famous Maine Photographic Workshop in Rockport, studying under Adams's former assistant John Sexton, as well as renowned photographers/printers George Tice, Tillman Crane, and Philip Trager. At a time when the general world of photography was fevered with prospects of "digital imaging," it might have been anachronistic to be studying the antique (some said dying) ways of making photographs with a view camera—the wooden box with accordion bellows, the photographer's head ducking beneath the dark cloth to study the image, inverted and reversed on the ground glass. To me, it felt anachronistic but right.

Proceeding into the darkroom to process film that has remained basically unchanged for decades, in fundamentally the same chemicals available to yesterday's masters, implied a bond of continuing and significant tradition. In an age of one-hour photo processing, it was important to me to acknowledge that the manipulating of pictures in the darkroom—adjusting light values, balancing components of composition—is at least half the creative process of photography. (Look just once at a straight, unmanipulated print of any of Adams's most famous images, and you might not be enticed to look again.)

For inspiration (and like any marriage, a joining of pictures and words needs inspiration), there was Acadia. Or to give proper credit, there was the Ultimate Inspirer, who, working through what we choose to call nature, had sculpted the felicitous lakes and shores, sea and sky, vales and dales that are known today as Acadia National Park.

Acadia, black-and-white photography, and poetry belong together. They afford similar blessings.

Consider photography. The word comes from the Greek words for "light" and "write." Photography is writing with light. The photographer—whether in the field or the darkroom—is a light-writer. In fine art photography, the *object* of a picture may be a rock, a river, the sea, or the sky, but the *subject*, always, is light. It is the light—pouring from the sky and dancing on the sea, bathing the rock and setting the river aflame—that the photographer uses to write silver verse. The work is both an art and a craft.

As an art, it can be very personal—even selfish. Any photographer who is honest will confess that he does not photograph so that others may see, but because *he* sees. Photography is his means of savoring and saving what would otherwise be but a fleeting feeling, sight, or experience. Photography lets him fix a moment not just on the film in his camera, but—more important—in his mind.

As a craft, photography can be daunting. Far from simple, it is a highly complex synthesis of sciences: optics and vision, physics and chemistry. A photographer must study those diverse disciplines, learn and understand them, then forget them. Or, he must at least push them far enough back in his mind to ensure that photography's craft is never permitted to be more than a servant to the art. Depth of field is never as important as depth of feeling.

Regarding photography and Acadia, the reader may ask: *Why photograph such a gloriously colorful place in black and white?*

Like several photographers before me, I do not "settle" for black-and-white film, I choose it. Why? Why has fine art photography so often been performed in monochrome? Surely color films could have been had by Adams. Or Edward Weston, Minor White, Alfred Stieglitz. Why, then, are their greatest photographs black and white?

To understand the allure of the medium, consider its nature. Black-and-white photography is based on silver. Silver is elemental and, accordingly, so is black-and-white photography. Being elemental, it provides a way of seeing through the distracting camouflage of color to the essence of a thing, a place. It offers a way of simplifying. Which is not to say diminishing. Seeing through to essence is not

reduction but expansion; it does not demean, but makes more profound. With its essential, monochrome palette, silver-print photography discovers truths that thought they were hiding. This ability to discover is its blessing.

Poetry does the same thing—it finds hiding truths. Or, to put it more accurately, poetry allows us to find them for ourselves. In a culture congested by too many words that say too little—a society in which what is spoken and what is meant are strangers—verse distills. And from its distillate—a heady nectar indeed—those who imbibe are encouraged to blend their own meanings, discover their own truths. The poet, after all, only sets down the poem; the reader writes it.

And Acadia? Here, visitors are free each day or night to fashion their own national park. No singular attraction commands them, for Acadia does not dazzle, as some parks do, with giant spectacle. It does not present the monumental cleaving of a Grand Canyon, the mysteriously predictable spoutings of a Yellowstone, the massive monoliths of a Yosemite. There are none of those here. Acadia—like black-and-white photography, like poetry—is essential. It was formed by the most primitive forces of nature, and its appeal always was and remains their interworkings.

To be sure, some people delight in the superlative boast that the sunrise is first visible in America from the top of Acadia's Cadillac Mountain, the highest peak on the Atlantic shoreline north of Rio. That, however, is not entirely true (the claim is justified only at certain times of the year, under certain conditions). Moreover, it is utterly irrelevant. Superlatives are not what make Acadia. Neither are they why so many people come here nor why these visitors return.

Acadia's joys are far simpler: the softly bubbling brook; the steady slapping of surf against shore; the shaded glade, all mossy and moist. These are the blessings with which Acadia cannot overwhelm, but can spiritually touch and salve the sensitive soul.

For the poet and photographer, the challenge of paying homage to Acadia is mostly one of not getting in the way. Stand back, enjoy, and don't complicate—that's what's required. In portraying Acadia, the great risk is undersimplification.

Another risk—and I confess the irony—is journalism. To a journalist, a national park is many things other than a repository of natural grace. It is a Babel of bureaucratic disputation, a victim of niggardly budgeters, a precarious precinct threatened by air that's not as clean as it looks as well as by two seemingly contra-dictory forces—overuse and neglect. To a journalist, those are a national park.

To a recovering journalist (for one is never wholly cured), such perceptions miss the point. A national park cannot be measured by counting dollars or visitors or ozone levels. Rather, one discovers the essence of the park in such gentle pursuits as attending the rush of a rivulet diligently polishing ancient rock to modern gleam; marveling at the improbably thin screech that is the voice of a great bald eagle soaring softly above; squinting into a dazzle of sun glare on water—an explosion of light that, by blinding us, enables us to see. We need to be with nature, be of nature—be nature. Ultimately, that is the purest form of beauty, but it is a beauty too often unheralded.

The purpose in these pages—in vision and verse—is to herald.

Raise the trumpet.

Jack Perkins
Acadia National Park
1999

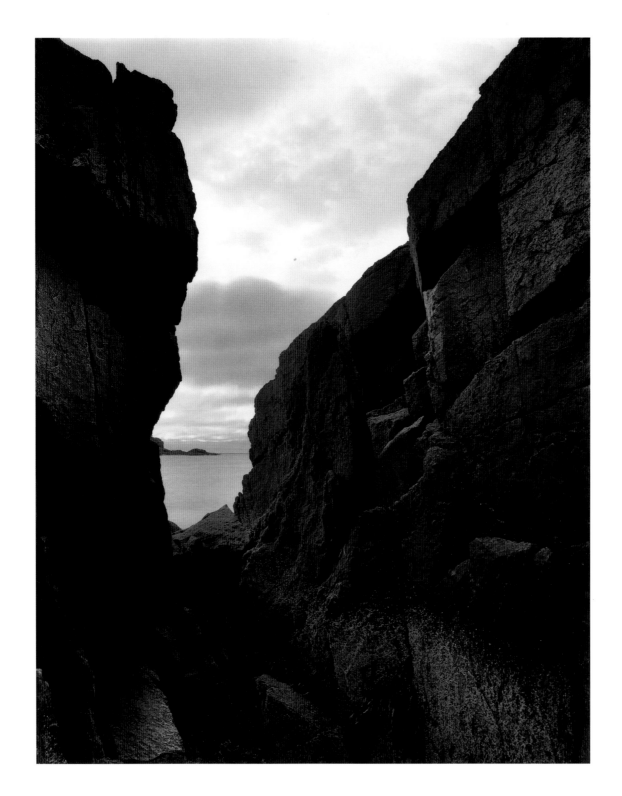

In the Beginning

Acadia sprang—as did all—from the sea.
From the sea it was that rose the land;
From the sea and the land, life.

And when did all begin to begin?
Before there were memories or minds to embrace them.
Guessers guess (though who can plumb the sum?)
Three hundred fifty million years. All those eons
Of grit and spoil, sand and soil,
Washed by rivers, pressed by seas, transmuted into rock;
Of rock that then erodes away in earth's immutable decay,
Reduced once more to grit and spoil, yet again to ground and soil;
Of lands that rise as seas subside
And then too soon are breached;
Of "Soon" that isn't (yet it is)
"Forever," never reached;
Of mountains interlinked that once were islands set apart;
Of mile-thick ice to scour and groove, advance and then depart.

There is no need for calendar or clock,
For here, time is told in rock.

Asters in Granite

Rock speaking mutely of first things and last,
Of unforeseen future and unrecalled past;
Echoing Paleozoic disasters,
While presaging towers to be crafted by masters.

Portents and history;
Prophecy, mystery.

Sometimes I feel overwhelmed by all this.
That's when I try, all this to dismiss,
 —And find asters.

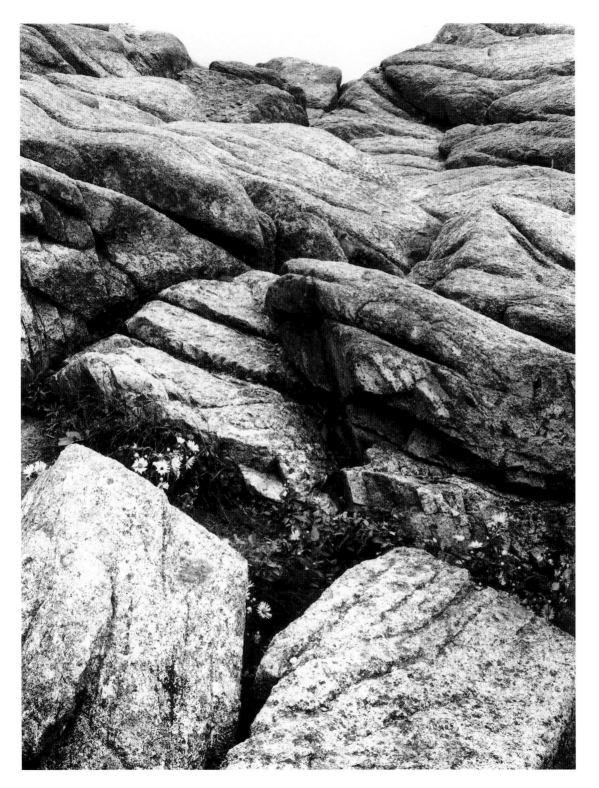

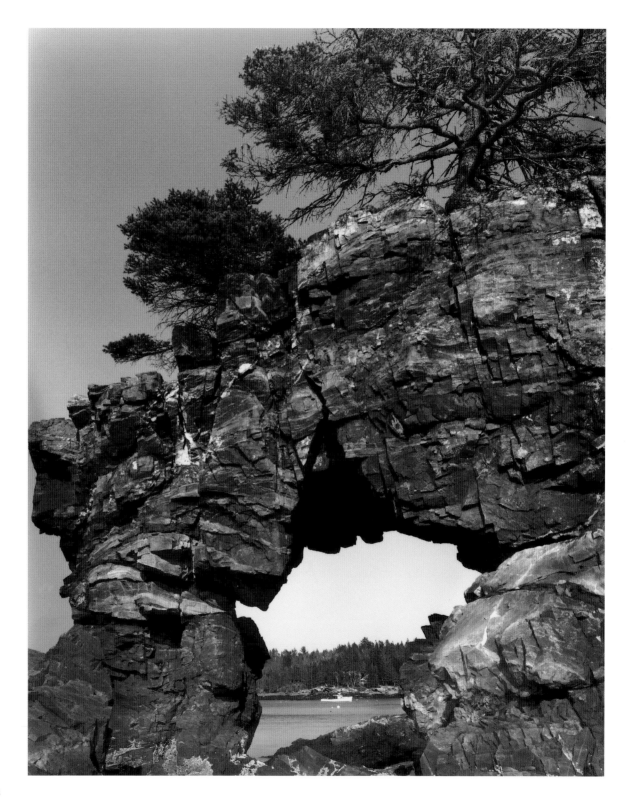

Here

If you would know Acadia,
Come first here.

Here to the brittle, pierced rock of Star Point,
Where if you stand in just the right place
At just the right time
Looking just the right way
(As few, of course, ever do)
The essence of Acadia,
Its organs and sense,
Lie layered in calling collage.

Here the resolute rock, and here the patient sea:
Eternal foes, reluctant partners,
Working together by working each against the other
In constant collusive collision.

Here the trees sprung from rock,
Hardy as must be in this not always temperate land.
Here the sky,
A vivid wash of newborn hope;
And here as well, bobbing free, the lobsterman,
Most rugged of all on this obdurate coast.

It is he that makes us ask: What lasts?
He, as we, will come and go;
Rock and sea—by our terms—stay.
Thus has Acadia always been:
The eternal surrounding the ephemeral;
The ephemeral, rarely noticing.

Starting here,
Starting now,
Let us notice.

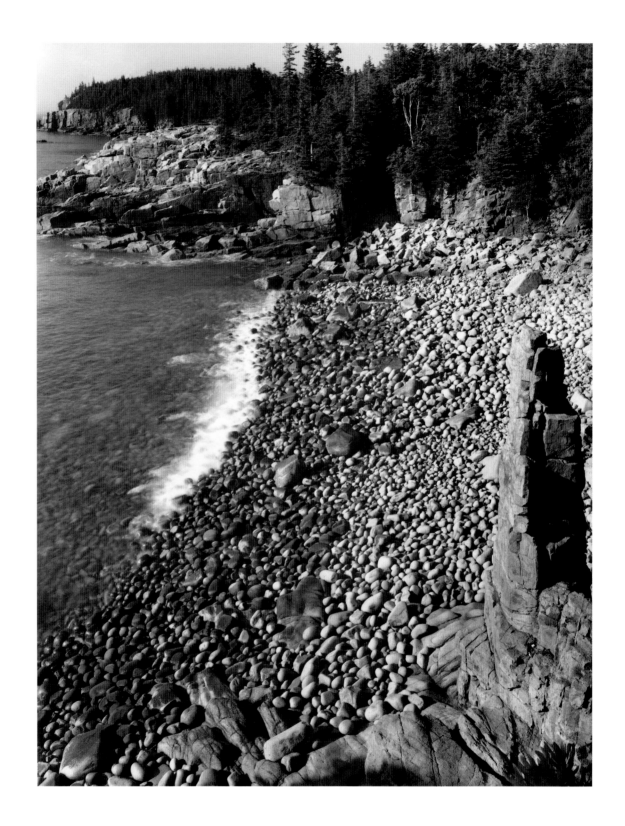

We, the Sea

Whenever we come to a shore, it's as though we've been urged
By some Force Undetermined to bring ourselves back from afar
To that place from which eons ago we so wetly emerged,
Crawling forth from the sea to begin to become what we are.

What are we? Terrestrials. Fully formed creatures of land—
So we think. And yet, strangely, whenever we can, we return.
We seek out a shore strewn with rock or a beach spread of sand,
And here we pay homage to Something; and here, try to learn.

To acknowledge that our blood is saltwater too. To allow
That the throb of the sea is our pulse. And so it must be.
We shall never escape from these waters—our then and our now.
The sea is always of us;
And we, evermore, of the sea.

Cadillac Sunrise

The clouds below are aglow
With the rose of the rise of the sun.
I didn't come to Cadillac to be the first to see it.
(Though that's why many come;
If there's a first, they want to be it.)
Instead, it was because
There was something I had to get done
Alone:

To say hello to the glow
Of the rose of the rise of the sun.
A salutation meant to make the newborn day your friend.
For every precious day whose glowing sunrise you attend,
You own.

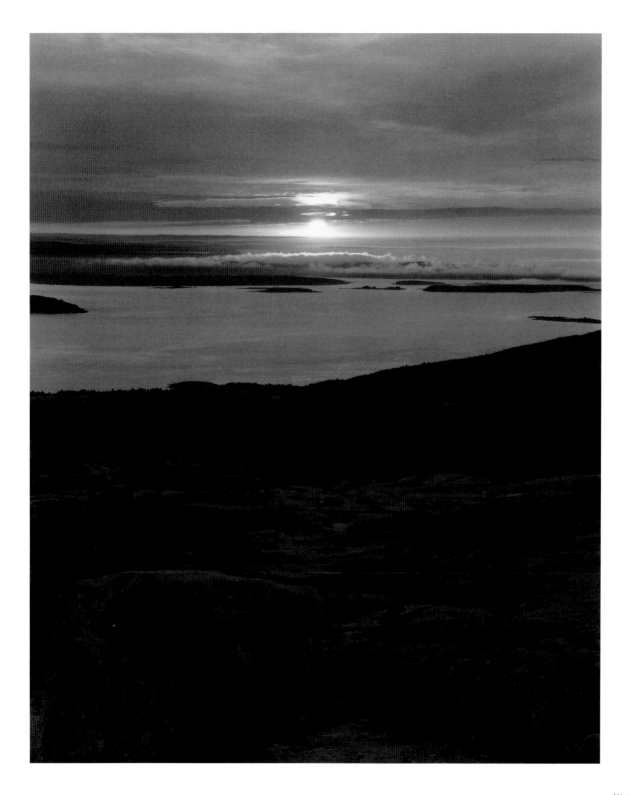

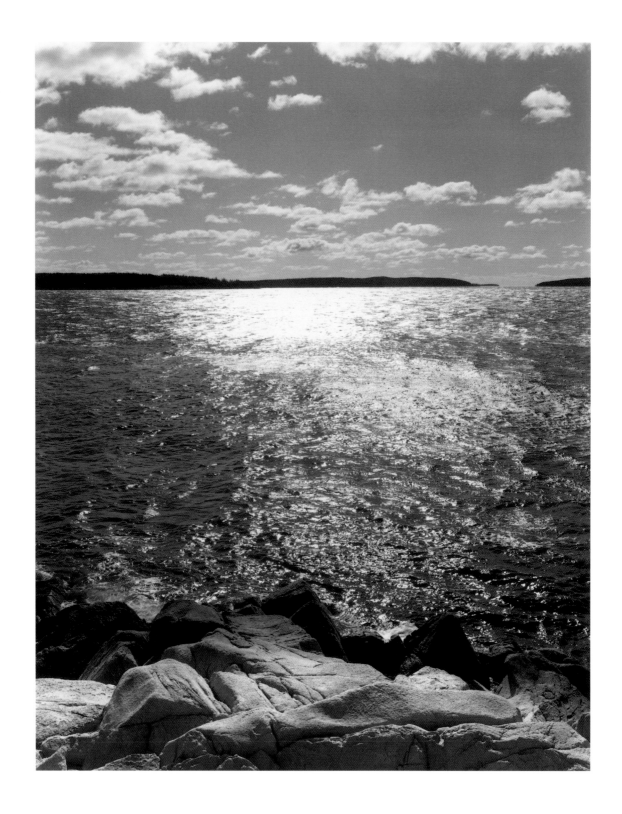

Sunglints / Godgleam

There are times when only the voiceless can speak,
The mute, alone, express the inexpressible.
This happens sometimes at Acadia's shore
When glowing rocks and sparkling sea
Make the Immanent seem imminent;
The Numinous, luminous.

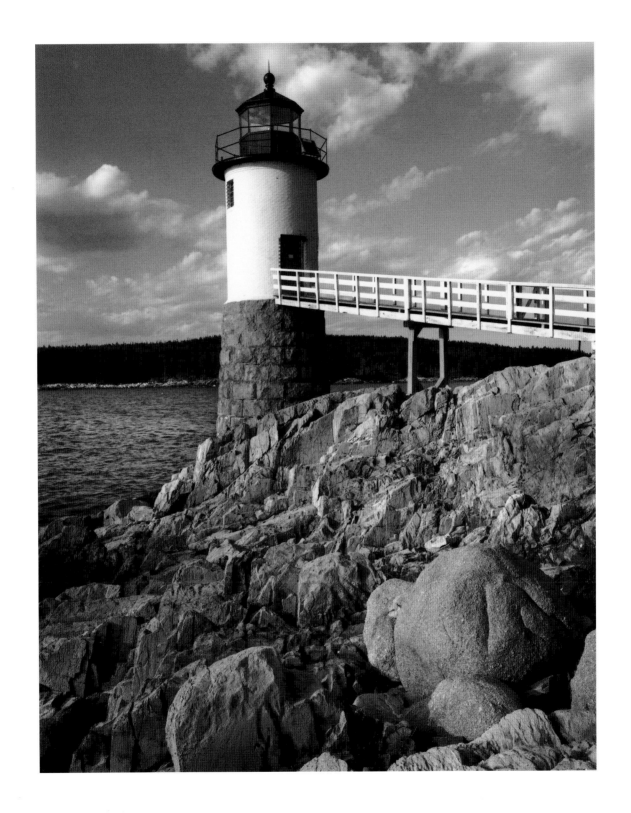

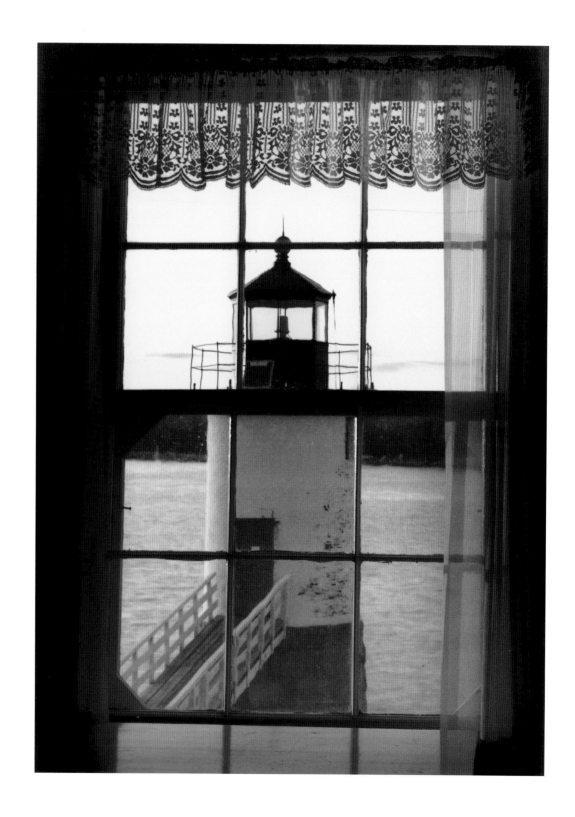

Used-To-Be

Let us go to Isle au Haut,
Island of used-to-be.

Where keepers used to tend the light
To bear their kin home safe at night,
Which meant they slept—if slept at all—
With one eye on their chamber wall
That should the light once fail to sweep,
The keeper, rising, had to keep.

Where the old pump used to raise a draft
Of coolness for a summer afternoon
When sun had parched the field
—An island's holy grace revealed.

Where used to be a sacred place
To celebrate that holy grace;
Wooden pews, kerosene chandelier
As simple as the faith lived here.

These are the memories we can see
On Isle au Haut—happy haunted place of used-to-be.

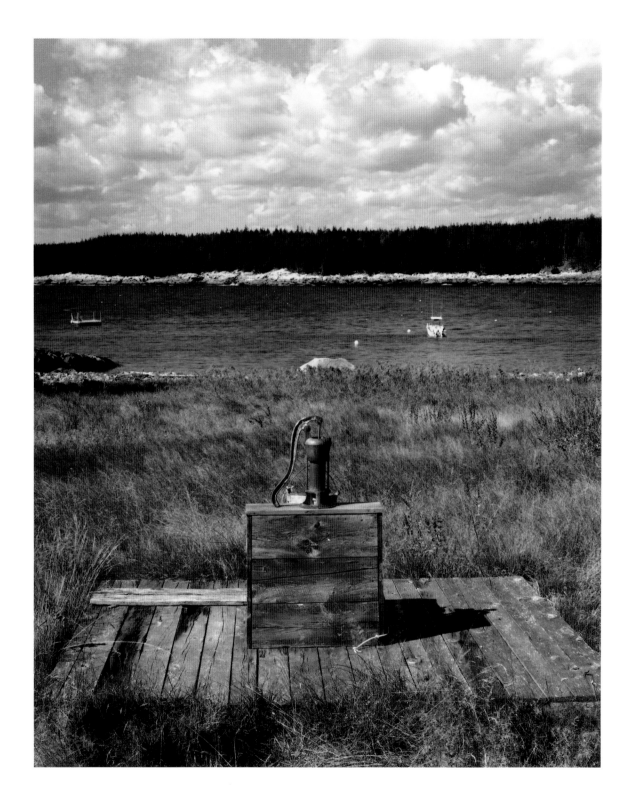

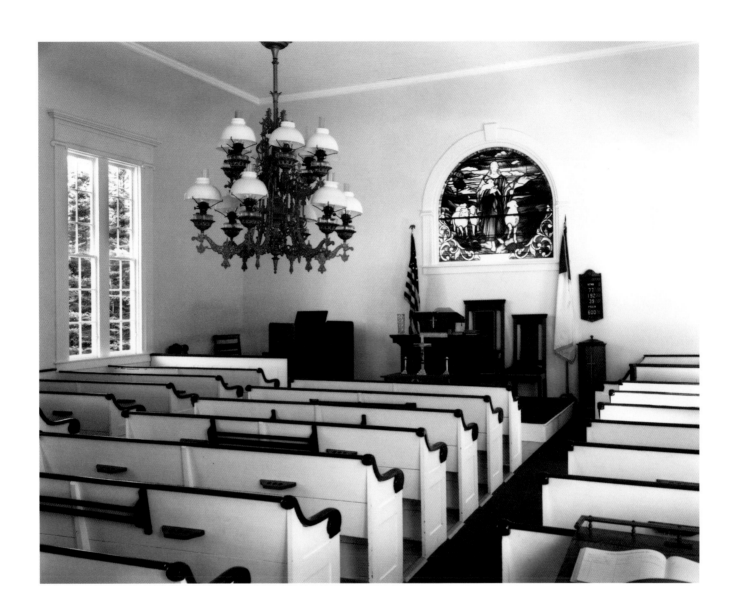

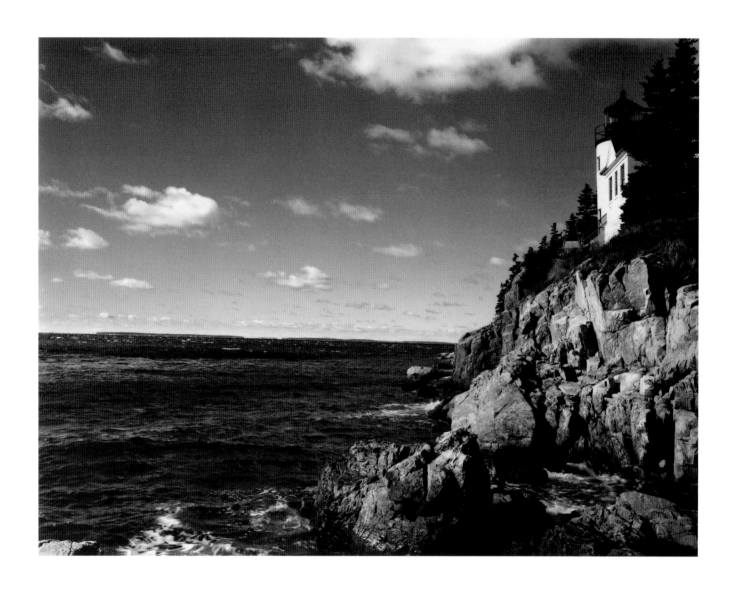

Faith

Granite ascending, rising from granite;
Steel upon brick upon stone.
I see this scene, this symbol of certainty,
Thinking: can I be alone
In puzzling why we squander our trust
On the seemingly certain; and why
We believe that a scene's being seen makes it so?
Why should we? We see the sky.
Or think that we see it. It spreads overhead,
All cerulean blue, we could swear.
But that's an illusion: the sky is not blue.
The sky is not really there.
We're certain we see it. We're wrong, so be it.
Credulity has us undone.
Believe in the seen? Maybe we shouldn't;
Instead, believe in the un–.

Unseen—the love that peopled these towers
And still attracts from afar
People loving themselves for loving lighthouses,
As they were and as they are.

Unseen—the faith that keepers clutched,
Unwilling to contravene.
For "Faith," the Book said, "is the substance of things
hoped for,
The evidence of things not seen."
Jesus told Thomas, who only when seeing
Finally felt relieved:
"Blessed are they that have not seen," He told him,
"Have not seen and yet have believed."

Invincible Invisibles:
The God we place above
That sky we only think we see
Up there. And faith. And love.
Those three are certain enough for me.
Henceforth this is my plan:
Believe much more in what I can't see,
Much less in what I can.

Dinghy

Whither the fisher who
(How many tides ago?)
Hauled the dinghy, draped the net
(Intending to scale? To mend?)
Then left. But why?

Shall we count him a victim of himself?
Having reached too far and grasped too much,
Had he stripped the life from the sea he relied on?
Had it, in turn, stripped him?

If so, we might remark his passing
To obscurity.
But there's little time to grieve for the fisher
While mourning the moribund sea.

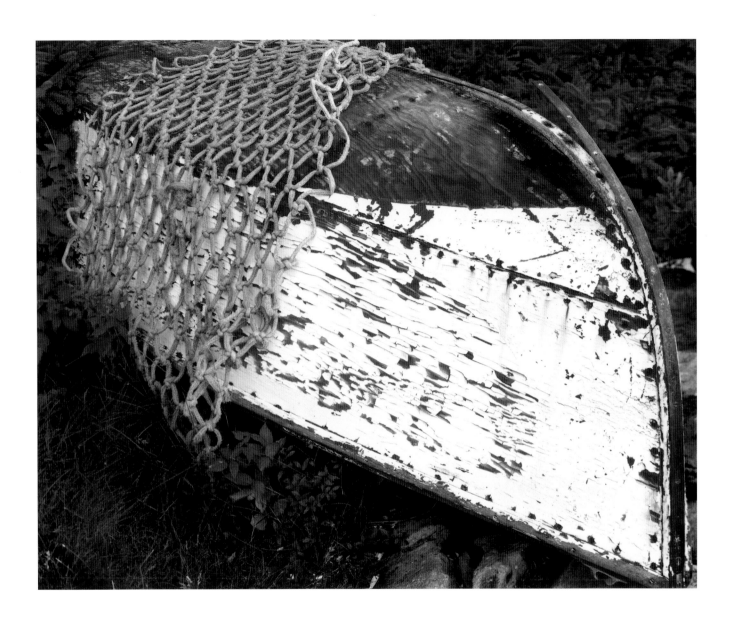

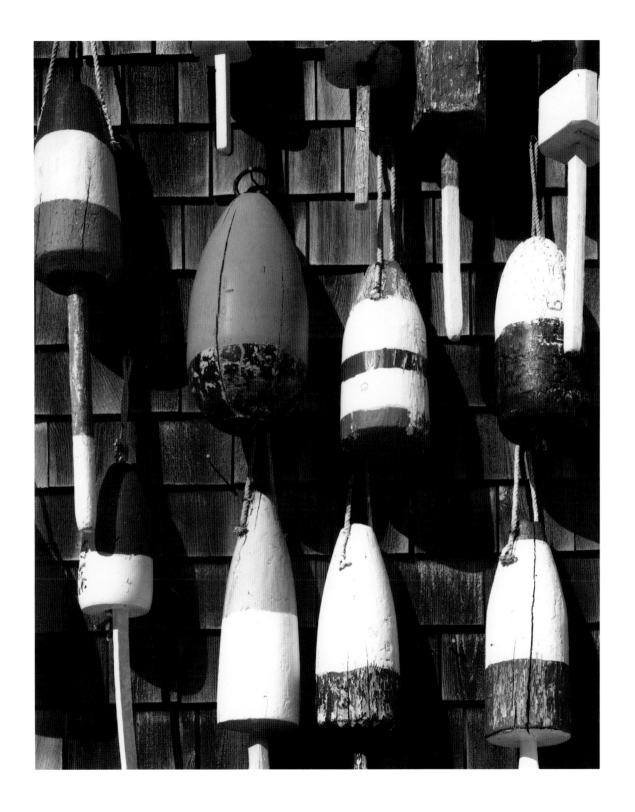

A Pond, a Marriage

At Bubble Pond, the hills contain the lake, as Nature wills.
But look again: the waters of the lake contain the hills.

I think this mutuality is what a marriage is:
No longer hers as only hers, or his as only his.
Instead, once man and woman as husband and wife are bound,
From then on, each contains the other;
In each, the other is found.

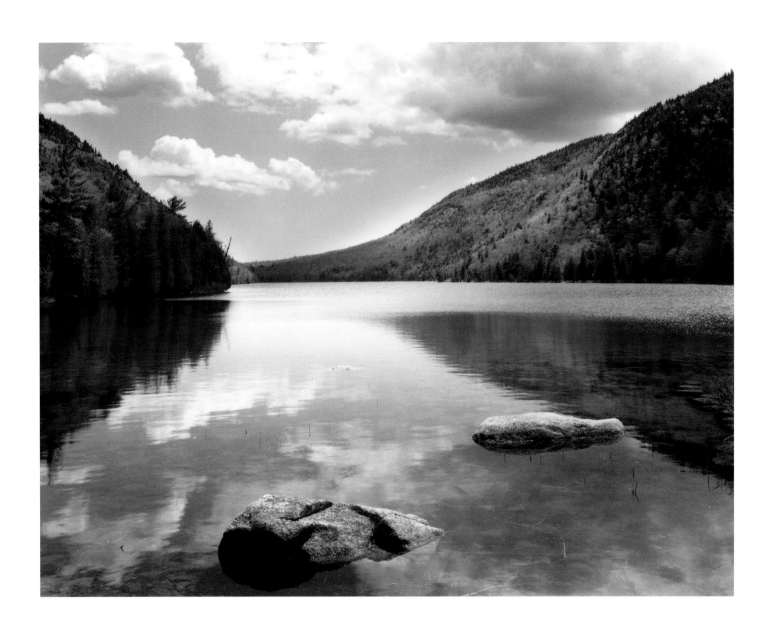

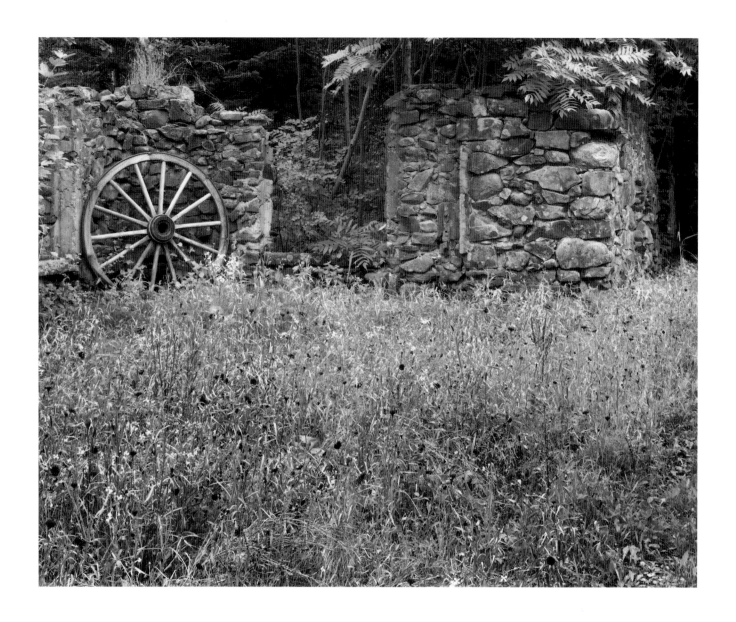

Garden Wall

We humans, trusting Genesis,
Presume dominion over all.
So, wresting rocks from nature's hold
Where stream or glacier let them fall,
We call them ours
And build a wall.

The wall says, *This belongs to us,*
A proof of Man's supremacy.
Here people rule and order reigns
And shall until eternity.
Such be our thoughts,
Our vanity.

But truth to tell
We'll soon be gone.
Then who will walk the paths we trod?
And when they find our futile wall,
Will they perhaps believe it odd
How we confused ourselves with God?

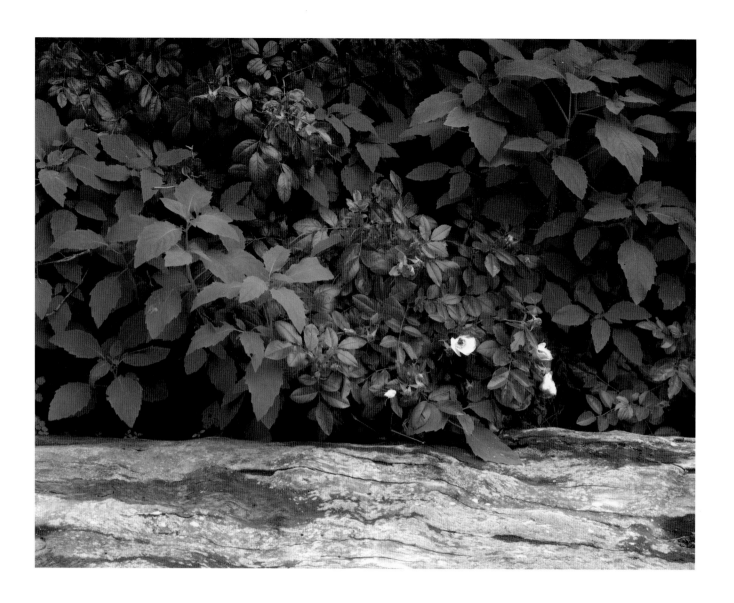

Wild Rose and Log

Beatrix, Patrick, what grace you did limn;
How even today your gardens beguile.
And Celia, planting on Appledore Isle
To inspire Childe's palette to colorful whim,
Inspire us all with your blossoms and mind.
Do you know—you three—that whenever we find
Your refulgent retreats, we smile?
This, we think, is how gardens should be.

Then, one day, on a shore, by a log fallen free,
We see a random rose, no Latin name,
Not planted here by hand of Man
To reproduce his cheer.
Not dusted, staked and pruned with care,
A part of some great gardener's plan.
None of that. No bloom of fame,
This humble rose, unnoticed here,
Receives not love, but gives it.
Knows not beauty; lives it.

We who, having traveled far,
Discover it (and few we are)
Feel a bit ambivalent:
At once assuming accident
(A misdirected seed or spore,
Coincidence and nothing more)
But also knowing that can't be.
We cannot credit mere fortuity.
Every flower needs a Planter; every garden is designed.
The rose before us was not planned
By the mind of a Thaxter, Chassé or Farrand,
But by the Original Mind.

Dewdrop

The lupine this morning embraces a dewdrop,
Soon in the sun to dry.
All I know of that drop of dew
Is that it knows more than I.
I know Now (at least a bit);
It knows Now and Then.
It has traveled Everywhere,
Lived through Everywhen.

Dipped from a stream by the hand of the Baptist,
It moistened the brow of God.
As sweat, it cooled the nape of a plowman
Busting Dakota sod.
One day it joined Niagara,
Thundering free and wild.
Another, drifted as a flake
To light on the lash of a child.
It plumped the grape that became the toast
To a new life bound together.
Rode the cloud of stormy night,
Fled in sunny weather.

It was ice that cleft recalcitrant crags,
Frost on April flowers.
Wyslawa translated its multifold guises
To verse for contemplative hours.
It fell with the rain that nourished the Bo,
Beneath which the Buddha found peace.
It rose from the breath of a dinosaur,
It spattered the tattered valise
Of an immigrant newly arrived with a dream
From a land where no dreams were allowed.
It was the tear of a dear young girl,
Loved, left, and proud,
(She never knew that not long after
It would be his tear too.)
It has been blood and flood and mud
And now, the morning dew.

What next? And where? We cannot know;
That lies beyond our ken.
But the drop of dew knows a thing or two:
Everywhere and Everywhen.

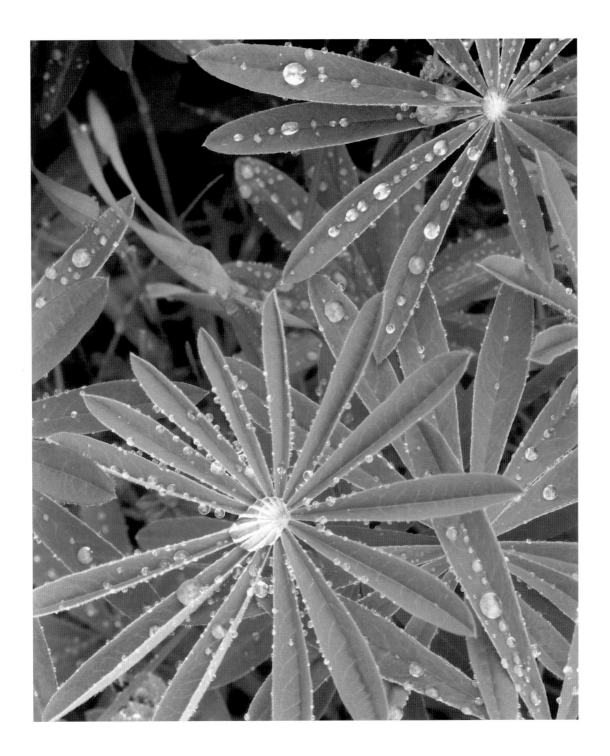

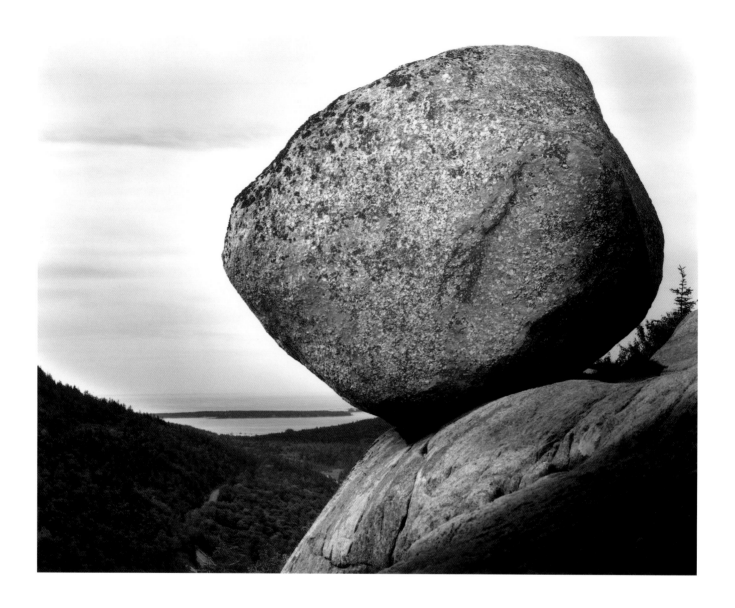

Bubble Rock

"Glacial erratic," the ranger calls it,
Brought here by forces it can't comprehend,
Delivered to this mountaintop,
Deposited on perilous perch
To balance here,
Equivocal,
Unstable,
Perhaps to plunge in the very next instant
(Isn't that always possible?)
Or, maybe, accorded grace
To stay for yet a while.
How long?
It does not know, nor need to know;
A rock brings its many yesterdays
Only as far as today,
Existing in now,
A symbol of solid uncertainty.

"Glacial erratic," the ranger calls it.
I think: "So am I."

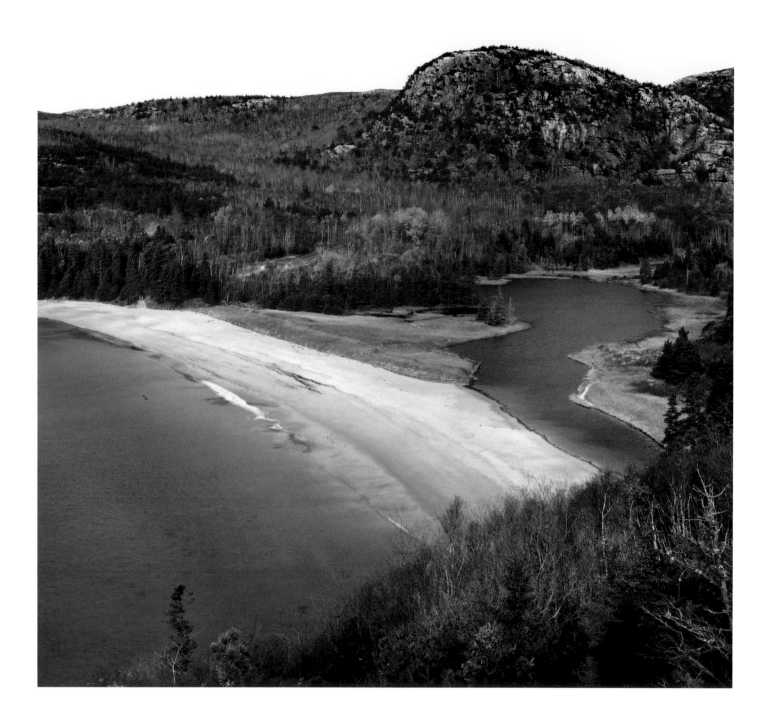

Sand Beach

Yesterday, bare feet skipped across the sand,
Tested water, fled to land,
Frisbees flew from hand to hand
Over picnics on the strand,
And dreams were dreamed
And plans were planned.

"You should have been here yesterday,"
I hear a voice from somewhere say.

This morning,
The tide was working overnight
To set the trampled sand aright.
Air is tangy, day is bright;
A great blue heron just took flight,
And not another soul's in sight.

"Yesterday," did someone say?
I'm glad we're here today.

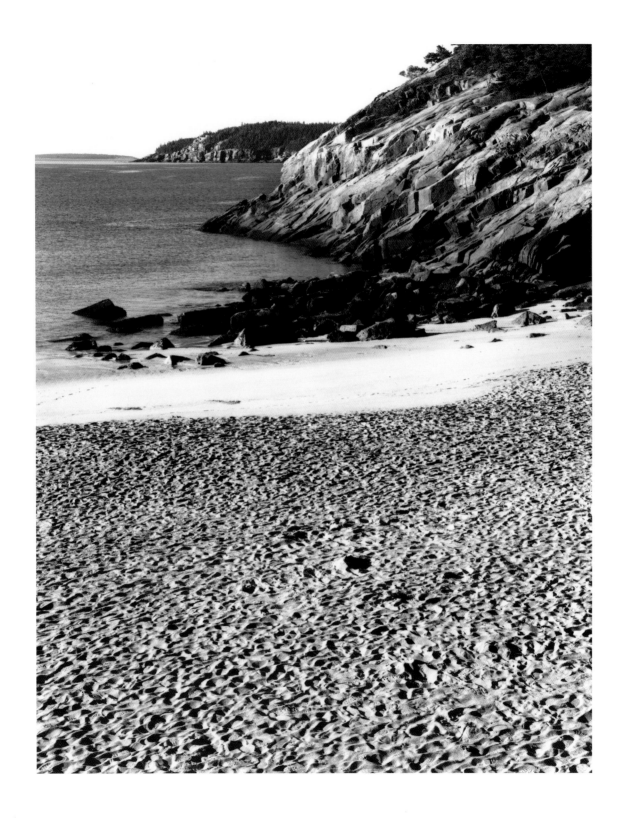

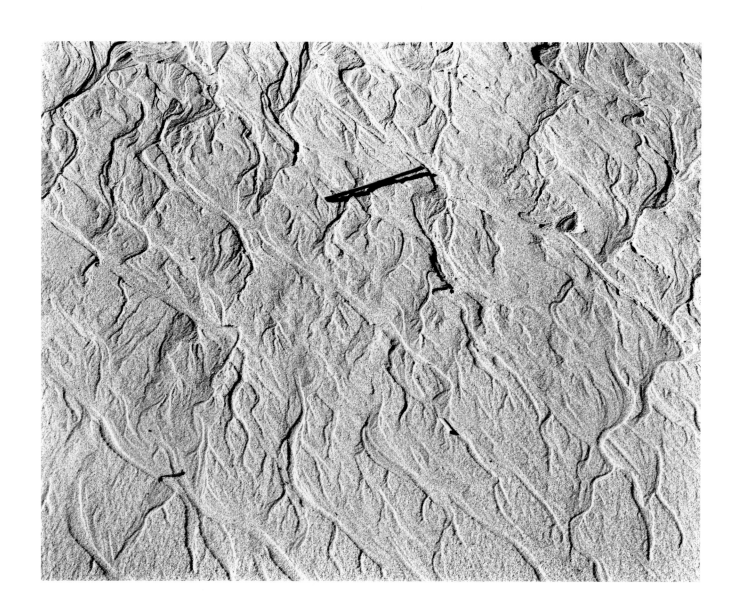

Hieroglyphs

Could it be
The hieroglyphs inscribed on morning sand
Are Life's encrypted rules,
All that we need understand
To live in concord,
Find our God,
Eschew disgrace and sin?

Could it be?

Decipher fast—
The tide is coming in.

Fog

The fog has come again to help us see.
Its visits seem to represent
The times we've grown too confident
That we are in control, and ought to be.

The fog, rebutting, sets about to lift
Bald Porcupine from out the sea,
From where we thought it would always be,
Casting both the isle and us adrift.

No day is this to hoist the schooner sails.
For how can helmsman navigate,
Avert the shoal, traverse the strait,
When what he counts upon—his vision—fails?

It's humbling—as I think it's meant to be.
When so much of our world's concealed,
There's something of ourselves revealed.
We need the fog to come to help us see.

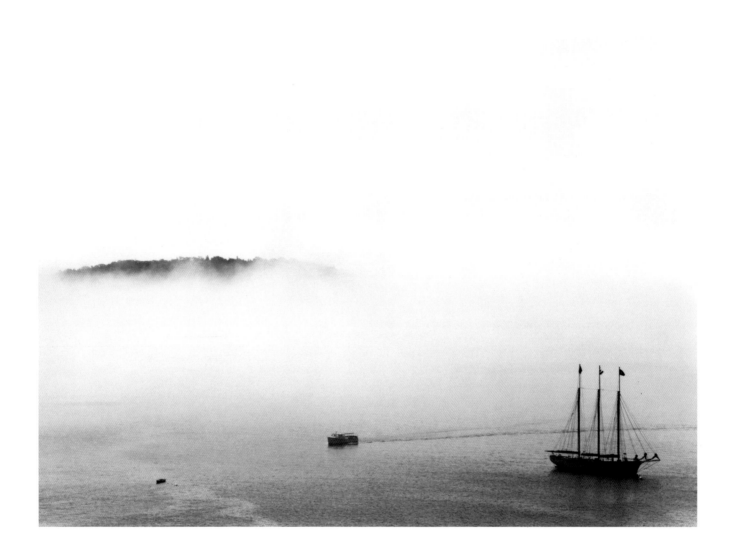

For Mary Jo

As kids we romped the dawnlit shore,
Mindless as morning,
Not knowing where to find the day
But thinking it would be nice to find it together.

Together we scrambled and clambered as young folks do,
Stopping to fling flat stones and when they didn't skip, we'd
laugh,
Because failing—failing together—is fine,
In the morning.

By midday, backs baked on sun-warmed rock,
We felt how right this was;
We understood the calculus:
That two as one are more than two.

Come afternoon, we two-adults-as-one,
Driftwood poles for walking sticks,
Tramped the woods where no one knows what's coming next,
But if a stumble comes, a fall, the other one is always there.
The other one *was* always there
As we plied the woods in lifelong quest
Of what?
Of us.

That is how we filled our gifted day:
With romps and skips; failures, falls, and help,
And love, always love.
Now, the day is almost done.

Come sit with me at sunset.
We know the secret of this hour:
That earth is turning, sun stands still.
And so, in fact, it's not the sun that soon will set,
But we.

Me?
I harbor no regret
As long as we can sit
 and set
 together.

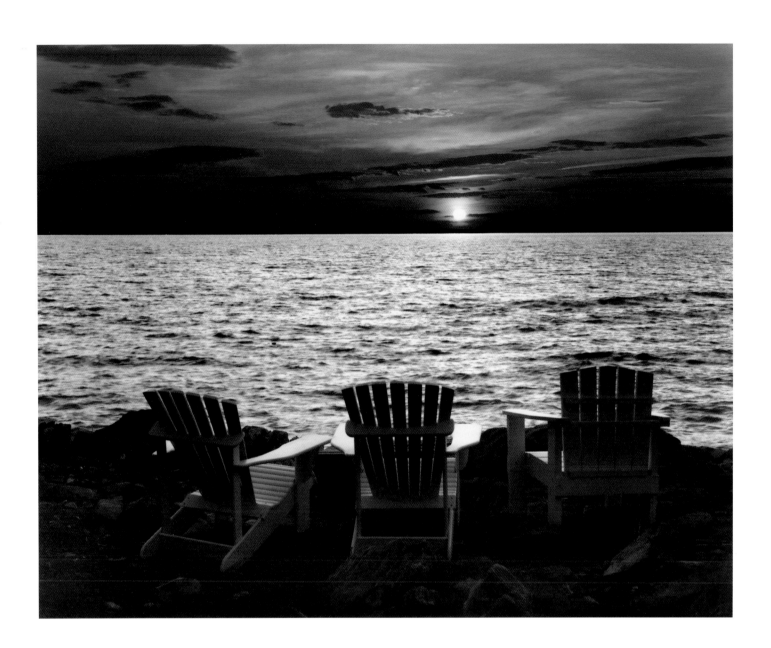

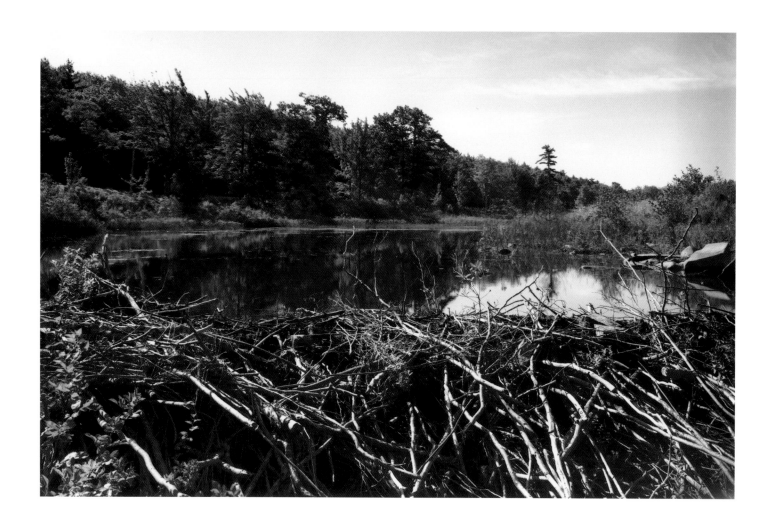

Damn Dam

Dam, say the beavers, ambitiously clever,
Wanting the water as moat for their den.

Damn, say the people, at such an endeavor,
Wanting no pond where a pond hasn't been.

So beavers at the water gate
Weave wondrous walls of limbs and leaves,
While sour people derogate.
Each behaves as each believes.

That's how it goes in life's exam:
Some pupils build while some decry;
Depends on which they're driven by:
The urge to dam,
The urge to damn.

Skylines

There:

My way is through chasms of concrete and glass;
Temples to wealth are the granites I pass;
I walk looking down, most of all, looking out.
It's hard to find Nature in mankind's redoubt.
I don't see the sky for the pall I am under.
No wonder.

Here:

My way is through meadow, past popples and pine.
The granites are mountains in faraway line.
I look all around, most of all, look on high,
And discover my God in the God-gifted sky.
I take as a blessing that dome I am under.
A wonder.

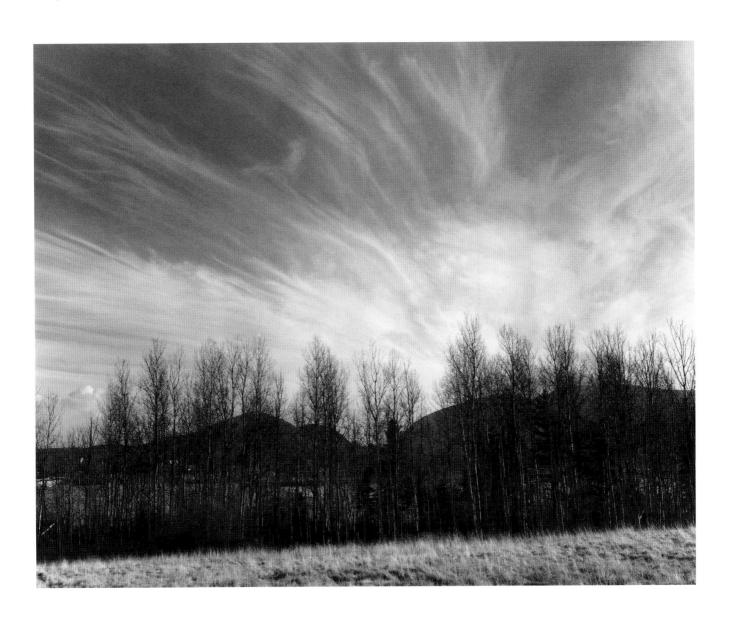

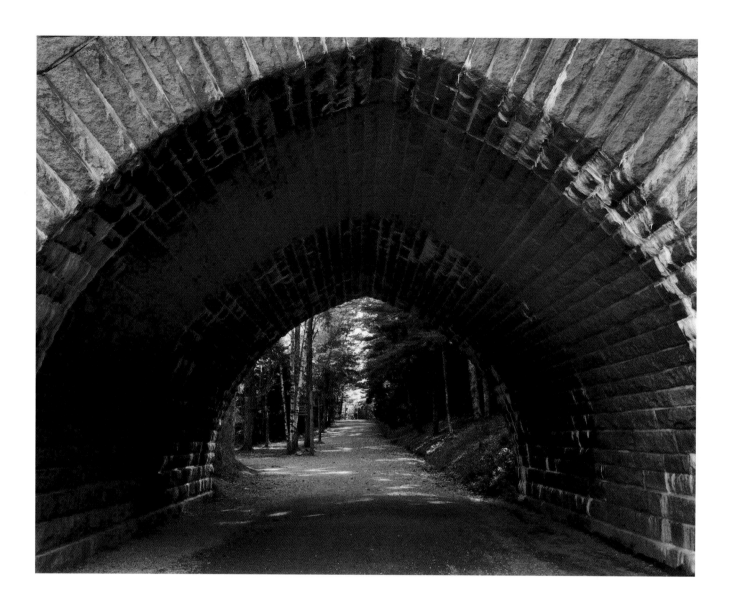

Paths

Once there was a path through an island jungle
(Where South of all meets North)
And it led to a place I had heard about
Where a stream sluices nimbly forth
Through a sinuous chute of polished stone
Burbling, "Ride me now, worry later."
I've got to say: That's a slippery, dippery, thump-a-rump way
For a fellow to cross the equator.

Another time, another path ascended to a height
From which the world spread before—a glory giving sight.
Looking down on rushing raptors,
Oh, I felt so tall.
But looking up at nothing (Everything)
Knew my size after all.

Yet another path led me out to a lagoon
To wade in warming waters and find myself so soon
In the company of dolphins who were most intent to see
What manner of creature this gangling, two-legged specimen might be.
And I reached out and touched them,
And they, in turn, touched me.

There have been many paths in this blessed life I've led,
But the most beguiling path is always
The path that beckons ahead.

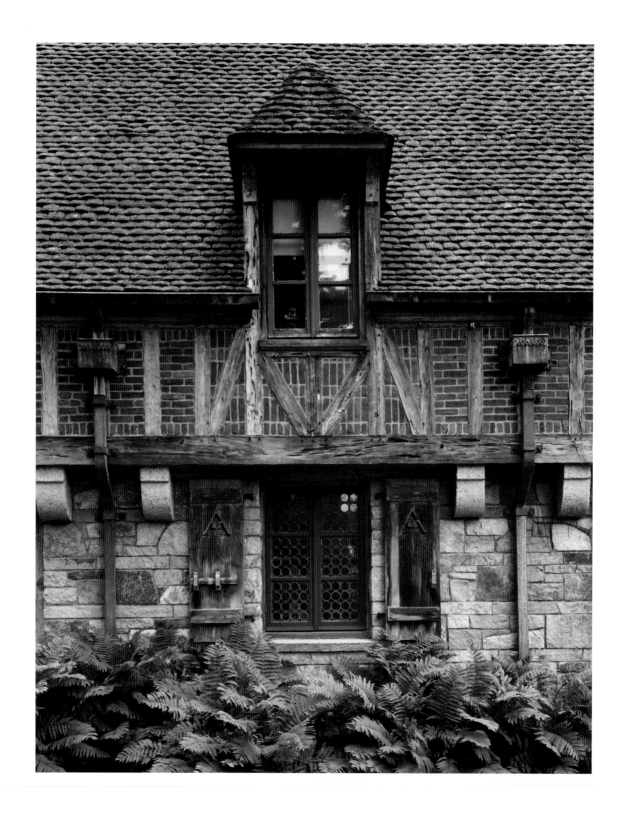

Creators

You asked: "Who created Acadia?"

Not thinking, I said, "The Creator."

Now, thinking, I know that's but part of the answer.

There were also those who came later:

People who, seeing, came to love;

Who, loving, chose to stay;

Who, staying, worked to guard and enhance

(Each in each's way).

These, too, were creators, who faceted, polished,

And set Acadia's gem.

It's plain to see reciprocity:

For as they made Acadia,

Acadia made them.

Carriage Ride

Most who come to Acadia to find her secret heart,
Don't.

Most, intent to know her as a love when they depart,
Won't.

They, wishing from an overlook to touch her glades and glens,
Can't.

Or apprehend her through a passing window or lens,
Shan't.

Too many won't take time to court,
It's motion they prefer.
So ninety-five percent of them
Meet five percent of her.

The rest, the blessed, praise those of old
Who had the vision, had the means,
To pry us, all these decades later,
Out of our infernal combustion machines
And into the woods on foot or bike
Or behind a team of horses.

The best way to Acadia's secret heart?
The Carriage Road, of course, is.

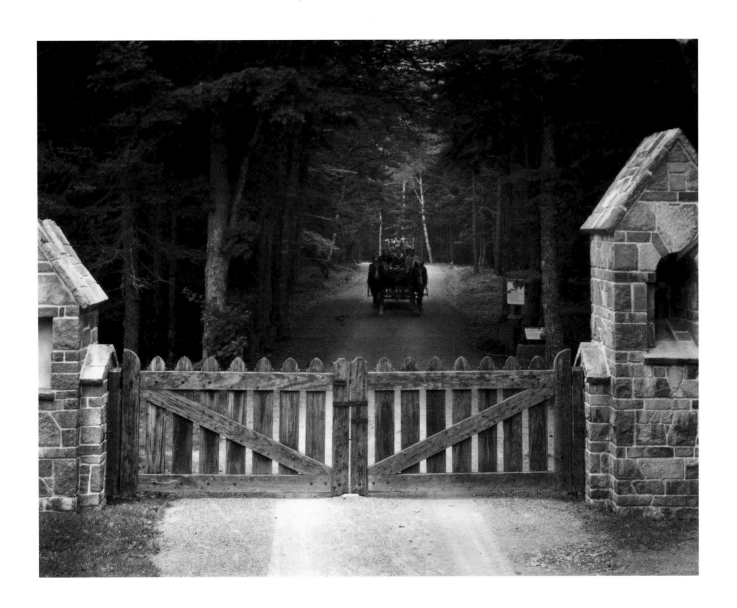

Angels

If you ever get to fretting and think
We live in an angel-less world,
A precinct bedeviled, beset by Beelzebubs,
Banners of evil unfurled,
Please, let us talk.
Come for a walk.

We'll hike the good woods of Acadia
Where nary a Satan is seen.
For Lucifer shrinks from the sweet smell of earth,
Preferring a sulfurous stench and a dearth
Of the fresh and the bright and the clean.
We'll find some mosquitoes (but not dread Anopheles)
Surely won't chance upon old Mephistopheles.
No demons dwell in this Satan-less realm,
Albeit with no thanks to maple or elm;
Nor is it the oak or the pine or the fir
That thwarts whatever you call him or her.

Think of Acadia's woods as a church:
Each spruce, a steeple;
We hikers, its people;
Its angels? Those heavenly birch.
See them gleaming angelically white,
Glowing, enrobed in all that is right.

Trees as angels? The doubter doubts.
Am I being awfully naïve?
No, I'm convinced that birches are angels,
But only for those who believe.

Try this: Inscribe a heartfelt prayer
On some fallen bark of birch.
If you believe, you might find that prayer answered
Next time you come here to church.

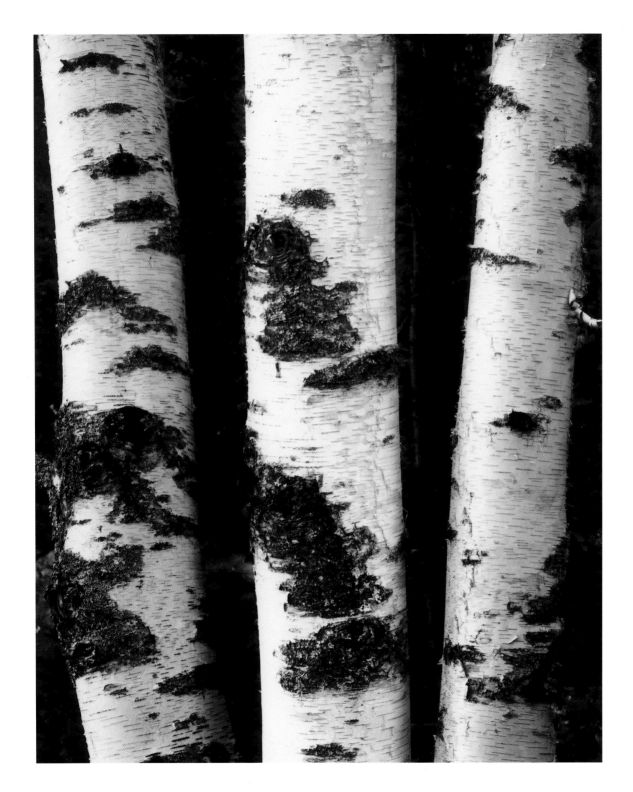

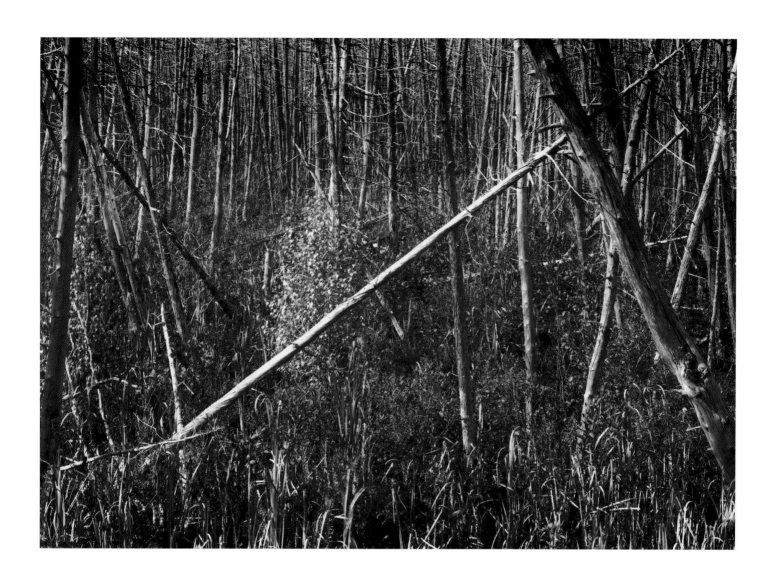

The Cycle

A friend surprised me today with a word,
A word which between us—best I recall—
Had never before been heard.
Even this time, it would have fluttered away
Had we been talking astrology.
Instead, a lump of lead, it lay,
Dread label of pathology.

When I left, I hefted a burden
That I could barely bear.
Nor could I manage to lose it;
It weighted me everywhere.
I took it to Acadia.
Surely the park could distract
Me from this diagnosed reality,
This fear that stalks as fact.
For Acadia is a fecund place,
Full of teeming life.
But wait. Acadia—also true—
Is a place where death is rife.

I know this spot as Deadwood Stand.
Here, the cycle shows true:
From life comes death (there's no escape)
But from death comes life anew.
And then comes death,
Comes life,
Comes death.
Each ending is a start.
And we're never the center of the cycle,
Just privileged, for now, to be part.

Birches in Snow

Some

When winters come,
Collect their things and head
With birds to warmer climes instead;
To Florida, perhaps, they pack and go
To any place likely to know no snow.

No snow in which proud birches take their winter stance,
Across whose bosom sparkle fairies dance,
No white-on-white of shadow play
For those who've gone away
To sun-warmed city.

Pity.

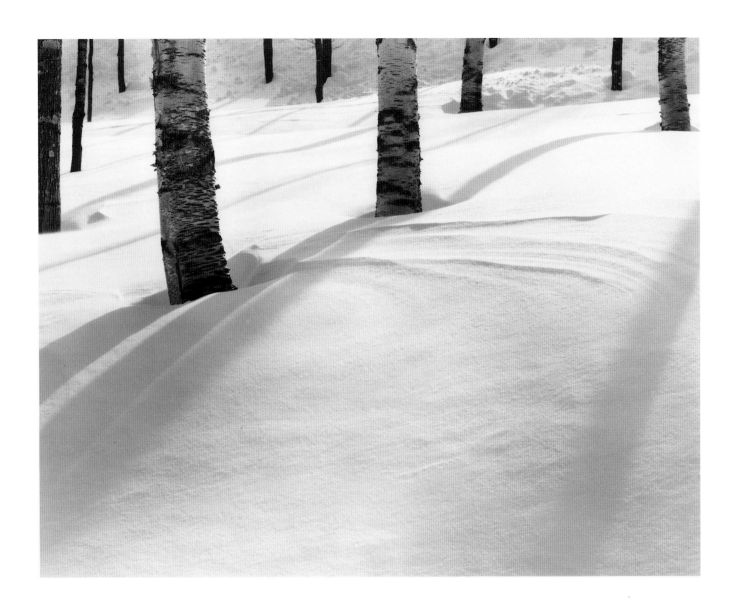

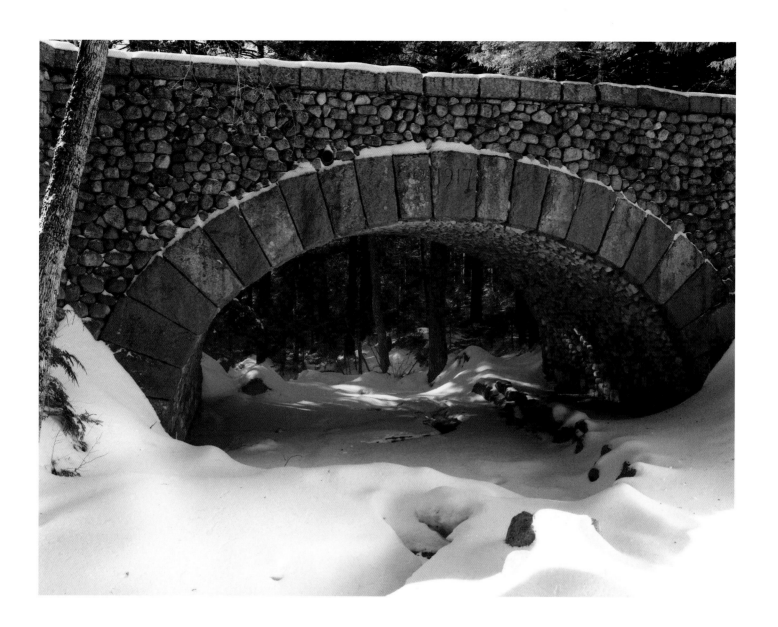

Cobblestone Bridge

If you make me an altar of stones do not build it of hewn stones;
for by wielding your tool upon them, you have profaned them.
Exodus 20:25

Simple stones from simple brook
Might not get a second look
If people of another day had simply looked the other way
And chosen as the paradigm
For their construction that sublimely clean geometry
Of chiseled stone in symmetry.

Instead, they chose another way.
Neither to architect's book of design
Nor draftsman's manual
Did they turn for inspiration—
But to the book made for that.
The ethic of Cobblestone Bridge
Was dictated ages ago.

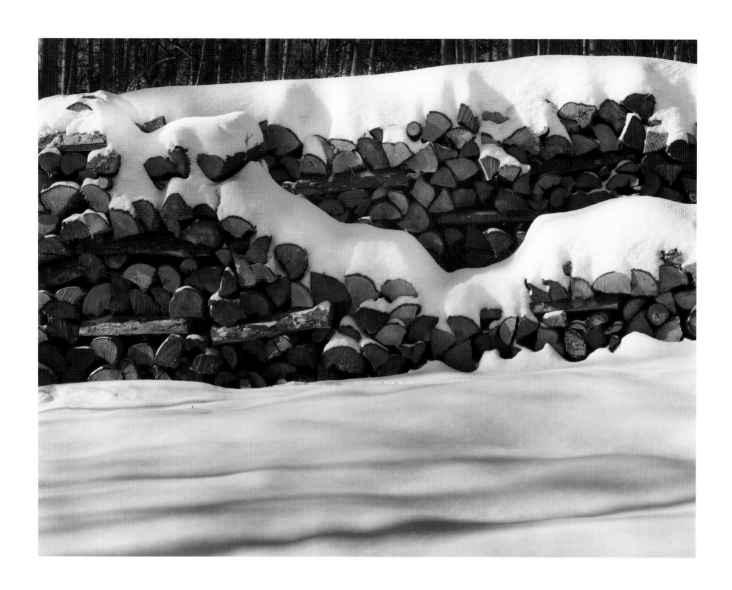

Winter's Warmth

What happened, you ask, to the kingly oak
That used to rule the meadow state?
It fell. At first, fell limb by limb
As Nature set about to trim;
But would the monarch abdicate?
It never occurred to him.
But time does turn (as dust to dust)
And tree as well as we need know
That others, too, need space to grow,
So one day, abdicate each monarch must.

What happened, you ask, to the kingly oak
Which served so many ways since who knows when?
It's serving still. Already having warmed us once,
It waits to warm again.

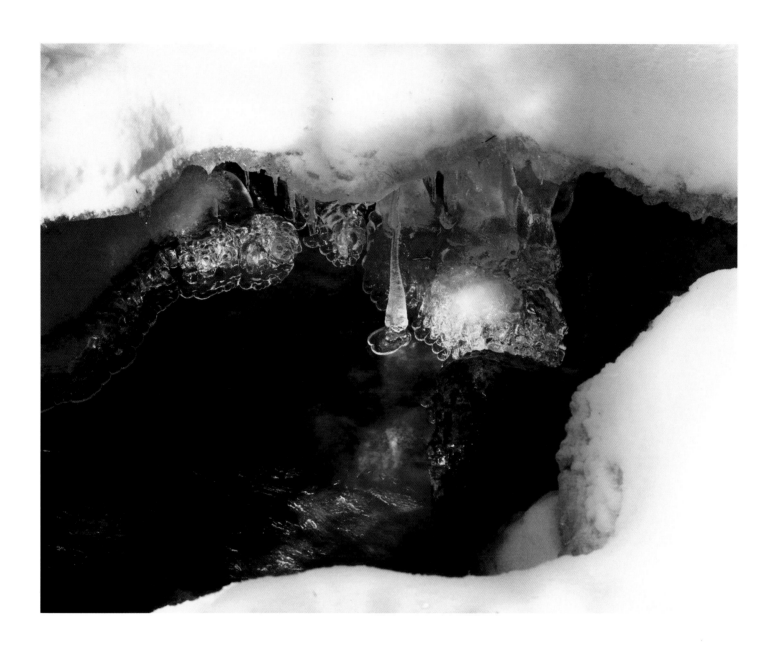

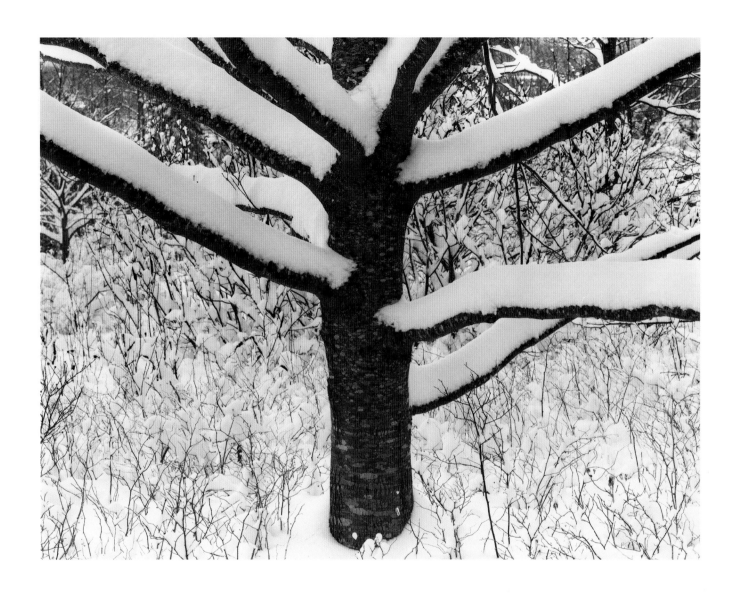

Snowflake

How fragile the snowflake:

A touch
 A breath
It's gone

Has Nature ever made a thing more tenuous,
 More tender?

And yet, think again next time you find yourself out in winter weather,
Of all the things those fragile flakes can do
When they stick together.

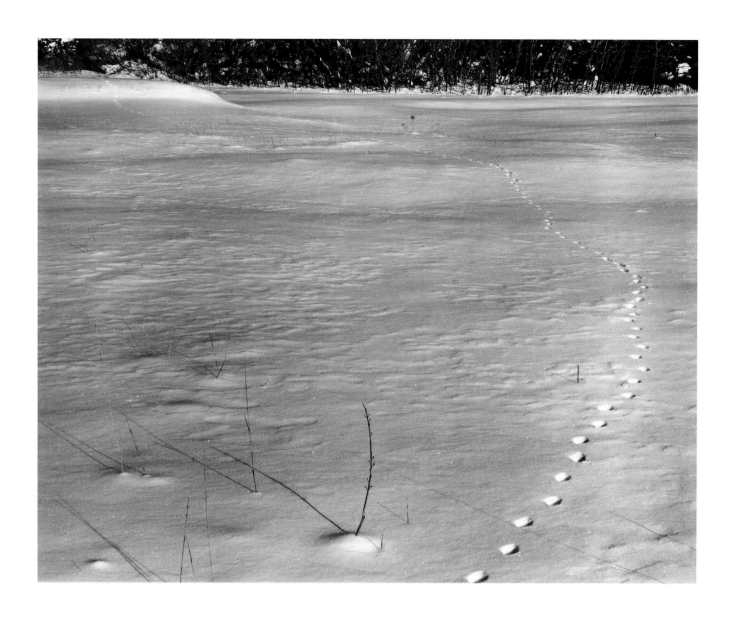

Meadow Foxtrot

Today I took a walk in the meadow where she had taken a walk.
Our snow tracks crossed, though just in space and not in time—
This time.

But I have been this way before. It sometimes seems I stalk
The lady. Not at all. Though I have come to know her well.
I've looked into her eyes and wished, while looking, I could climb
Into her soul. I've wondered if perhaps it might not be
That she, the while, was also looking, wishing, just like me.
I'd like to think beneath that rufous robe a friend might dwell.

Now, that's not realistic, the Cynic will deplore,
Ascribing human feelings to an animal that way.

I'm not ascribing, I'll reply, I'm wishing, nothing more;
A meadow walker's wistful dream that one bright snowy day,
That vixen, trotting through the meadow, my tracks here will see;
And maybe then—How lovely to hope!—*she* might think about *me.*

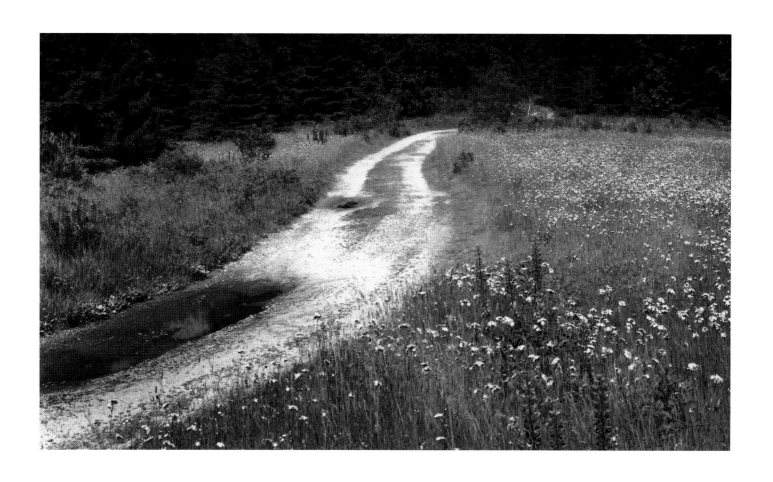

The Road That Winds to Woods

It wends and winds through freckled field
To find the woods and disappear;
And where from there?
Those who do not know
Receive no absolution from the puddled, island road.

But I its secrets share,
And, sharing, am renewed.
The jangles of the day are calmed,
Its toxins laved away,
Its vexing, pressing problems
Fade with fading day.
It's time at last to bid the afternoon a sweet Shalom,
And walk the road that winds to woods—

The road that takes me home.

To Be a Bridge

To be a bridge is to rise above,
To reach across,
To span;
 Bringing together two sides opposed,
 Affording passage where none was had.
It is doing all this but seeming, the while, to do naught.

Blessed be the peacemaker,
Holy be the bridge.

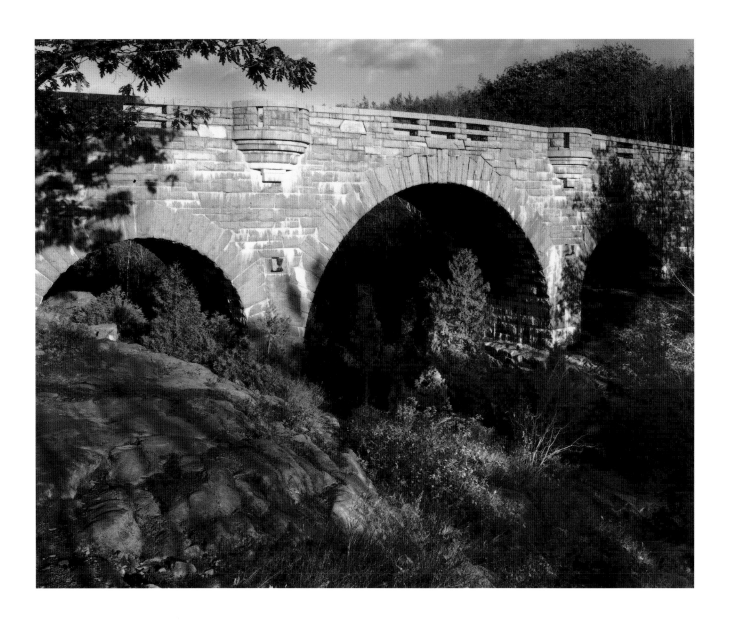

Shining Shad

Are you willing to learn from a tree?
A tree that is small and so commonly drear
That it goes hardly noticed for most of the year?
Now what, pray, can that say to me?

Well, look at it now in the spring,
At this moment with all of its blossoms alight
For a brief burst of glory, its pride shining bright
In a singular, spring-ular fling.

There are people this tree can define:
Feeling small, without purpose, unnoticed each day;
Don't they know that with God's light within, even they
Like the shad, for a moment, can shine?

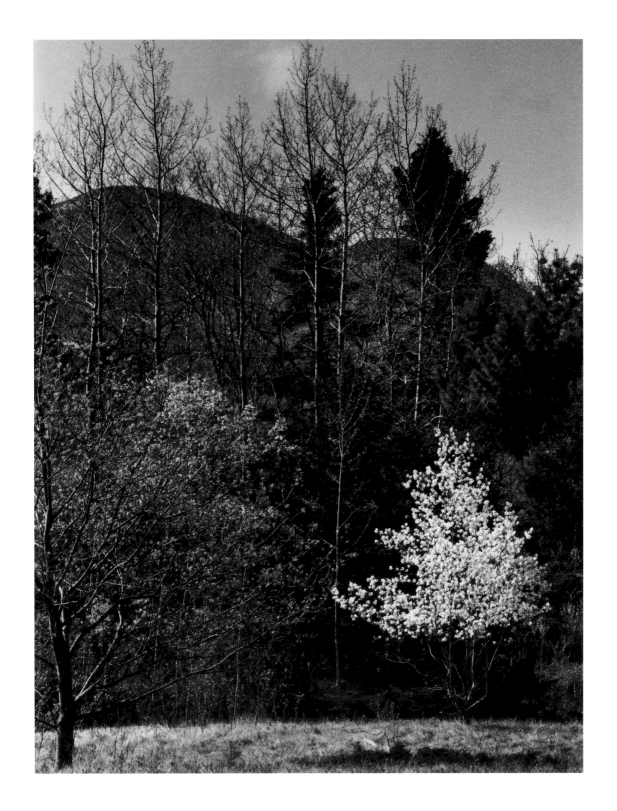

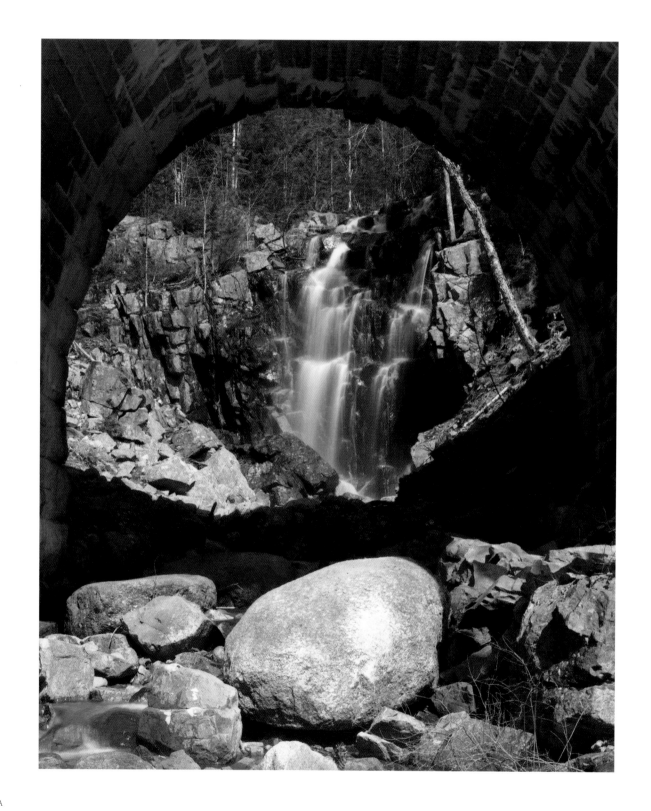

Waterfall Bridge

A man of wealth, a man of vision
Went into the woods to start
To execute a bold decision:
Here, to craft a work of art.

Today, with many decades passed,
That art still spans its sometime stream,
A tribute that long will last
To that good man who built a dream.

Still, visitor, before you start
To praise that benefactor's name,
Concede that to the real art,
His bridge is but a frame.

Spring

So this is how spring comes to Acadia:
Bubbling out of the forest on Cadillac's flank,
It tumbles, cascades
Giggles, exults
Cunningly using winter's own snow
To wash lagging winter away.

Its vernal voice is gentle,
A soft susurration,
But somehow, it will be heard
By far-away birds
Who will know from the sound of this distant splash
That it's time to be a-wing.

Spring has come to Acadia
With a bubbling, beckoning, nurturing spring.

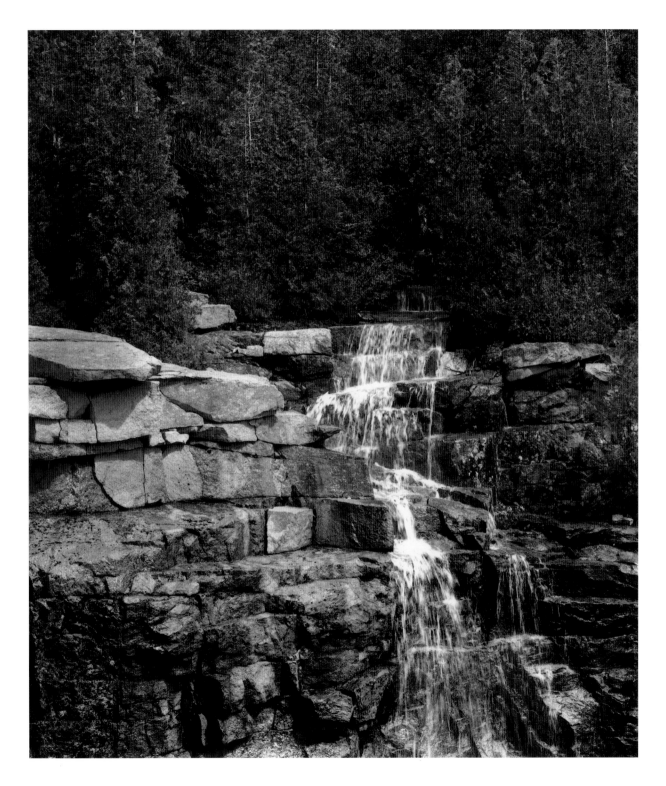

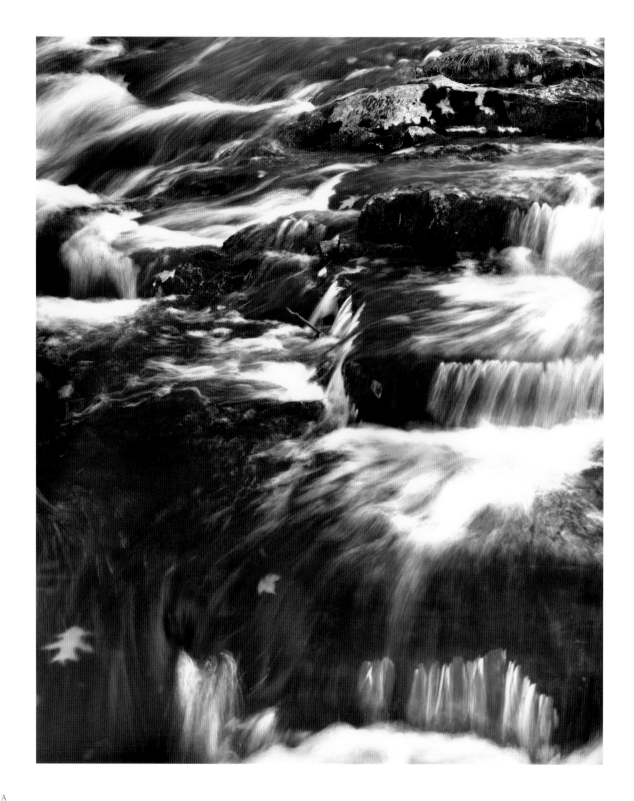

Water's Work

It's only fair.
Water does so much around here.
Floats the boats,
Shapes the shore;
Frozen, it scoured the mountain tops;
Pooled, slakes the thirst of bird and beast;
Flowing, ferries nourishment;
Soaking, greens the grass;
Gathered, mirrors the beauty
Of this most beautiful place.

All in all, it does so much,
Working night and day,
It's only fair
In a spot so merry,
It gets a chance to play.

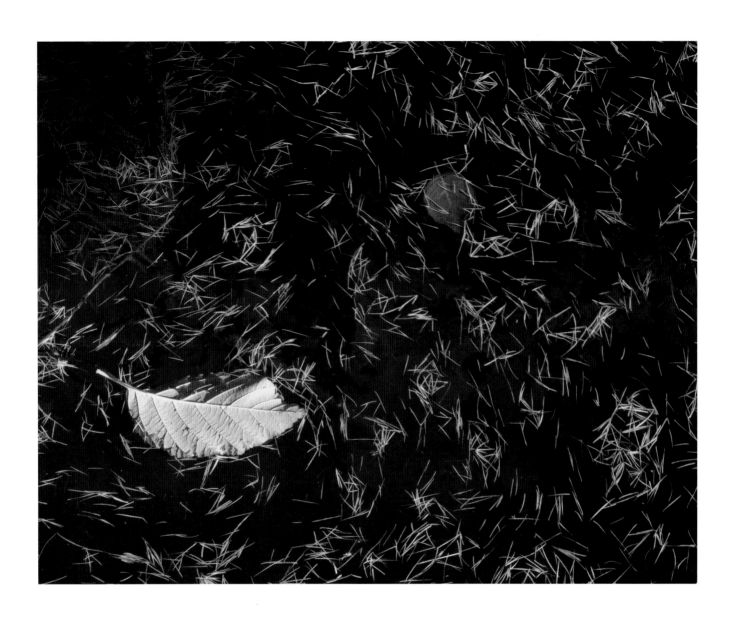

Go

Had enough of my pious preachments?
Just one more, if I may:

Unless you intend to live posthumously,
Go. Find beauty today.

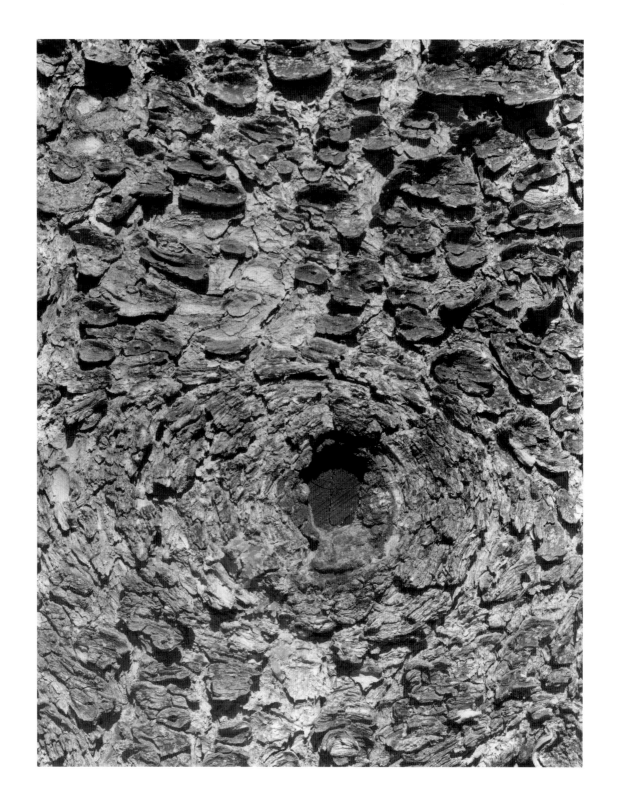

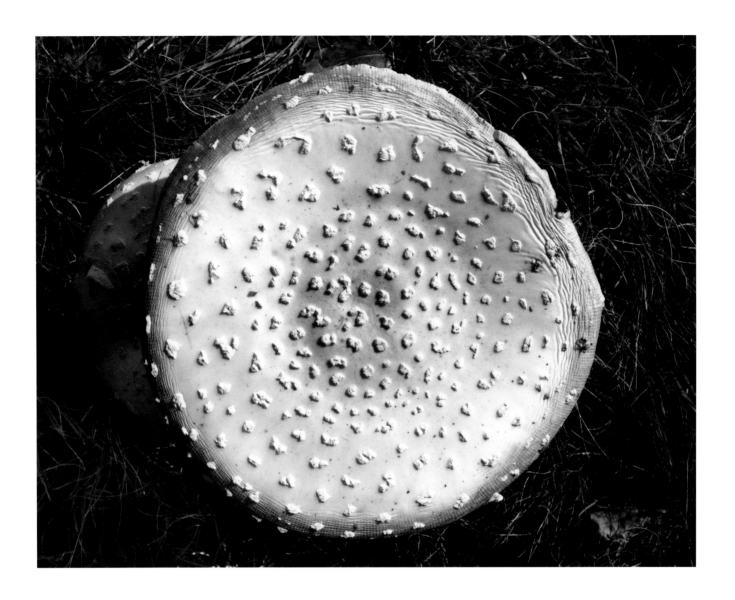

Two Rocks on the Beach

Sometimes

Two objects, quite disparate,

Forged of different stuff in crucibles apart,

Are somehow—by forces we can name but not know—brought together.

And the forces are right.

They fit.

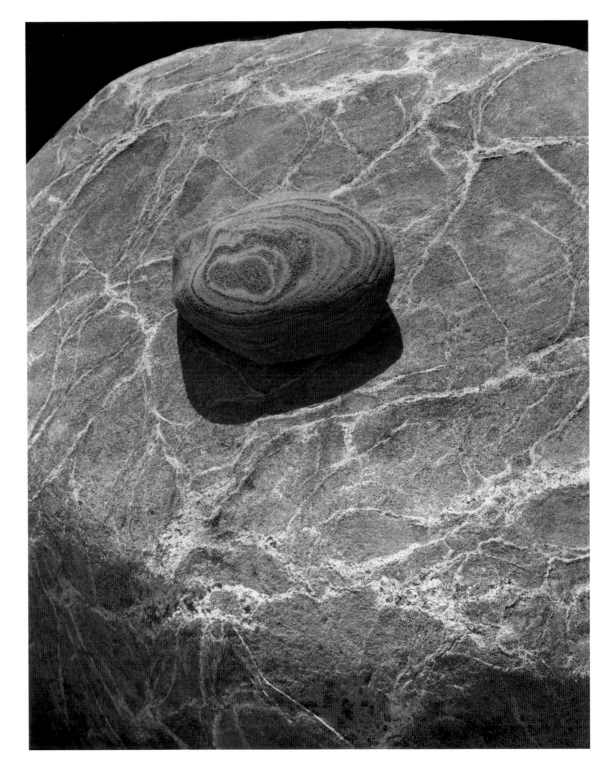

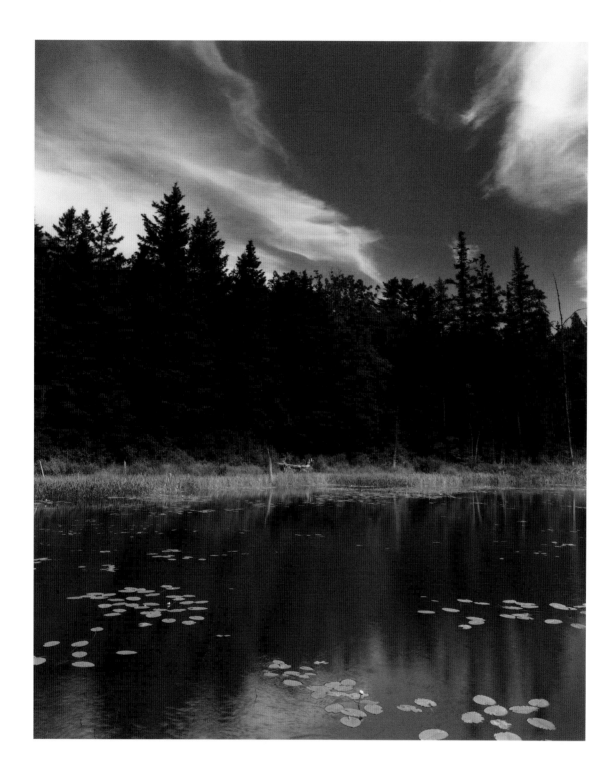

Who Cares?

Who cares if waters aren't as pure as once they used to be?
The lily pond out by the woods looks pure enough to me.
The creatures in it, or dependent on it, I can't see,
So maybe—I don't know—if given voice they might agree
With all the despairs.
Who cares?

Who cares if air, by some reports, is not completely clean?
A sky like this lets us forget that even when unseen,
The effluents of affluence can do things rather mean
To air. But then, perhaps, these days we can't afford pristine
In our affairs.
Who cares?

Who cares?
The question's not rhetorical; it begs us to respond.
And how we answer means a lot to places like the pond.
Let not their beauty lull us. When all is said and done,
I hope Whoever's keeping track will mark *me* down as one—

Who cares.

Friends of *Acadia*

It seems an apt time to thank some friends. That is, Friends.

The preceding verse asked "Who cares?" Let me introduce you to a group of folks who care very keenly about this place so many of us love—Acadia—and have learned to translate their caring into salutary action.

Back in the mid-eighties, when government funding for national parks was eroding, when Acadia's natural and cultural resources were beginning to suffer from neglect, these dedicated people founded a private citizen support group for the park called "Friends of Acadia."

They have earned the name again and again. They have raised money, enlisted volunteers, lobbied for increased government aid, guided policy planning, and rallied public support. They dreamed of rehabilitating Acadia's unique 44-mile network of Carriage Roads, fallen into disrepair, and then made that dream come true. Identifying generous contributors, they managed to have two carriages made specially accessible for people with disabilities and placed into service on those roads. Through thousands of hours of volunteer labor, they did trail work for which the government had no budget. Rallying public interest, they forestalled an extensive forest clear-cut planned along the park's boundary. They undertook a multimillion dollar project of reclaiming lost foot trails in the park and between the park and adjacent communities in addition to restoring miles of trails still in use.

They did all this and continue to do so because they care. It was their caring and participation that made possible the publication of this book. For that, I am grateful.

But then everyone who sees, visits, uses, and enjoys Acadia National Park can be grateful to Friends of Acadia. They welcome support and encourage new members. They can be reached at:

Friends of Acadia
P.O. Box 725
Bar Harbor, ME 04609

Telephone: 207–288–3340
Website: http//www.friendsofacadia.org

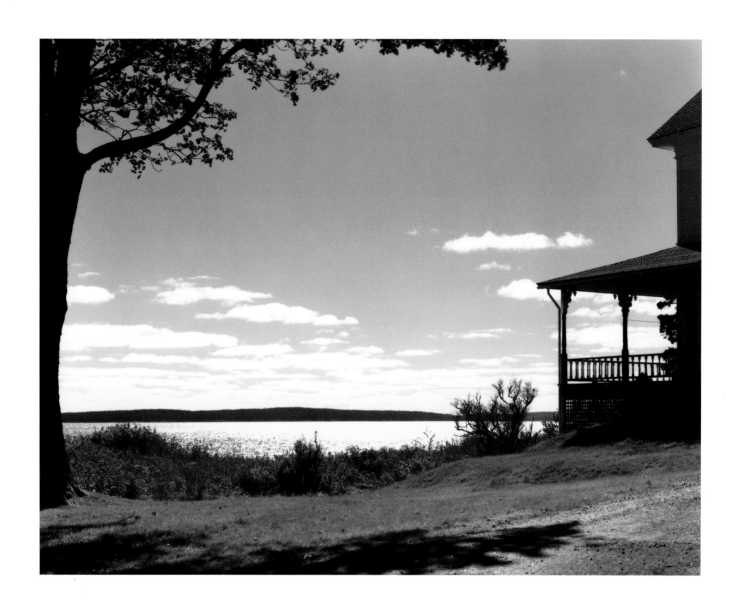

118:24

Our final song, sung by the Psalmist,
Does not need my voice in it:

This is the day the Lord has made
Let us be glad and rejoice in it.

Photographs and Locations

The photographs of Acadia National Park and environs were made with 4x5 view cameras (a Zone VI Field camera and a Wismer Technical) with Schneider lenses, mounted on a Ries tripod. The film used was Kodak T-Max 100 Readyload, and was developed in T-Max RS using a Jobo rotary processor. Photographs were printed on Forte Papers developed in Zone VI chemicals and were selenium toned.

Credit where due:

Peter Blaiwas designed
Brian Hotchkiss and Mary Speaker edited
Ansel Adams, not knowing, inspired
John Sexton, George Tice, and Tillman Crane, fully knowing, taught
Phil and Ina Trager both taught and counseled
Down East Books' Neale Sweet, Karin Womer,
Alice Devine, and Chris Cornell guided
The Holy Spirit enabled
God granted

I praise all.